INDEX

She is Risen	Page 3
Over the Hill	Page 5
The Way Forward	Page 7
River Birth	Page 9
Red, White and Blue	Page 11
Paved Paths	Page 13
The Chalice	Page 15
Still Standing	Page 17
Memoriam	Page 19
From Psalm 147	Page 21
The Mist	Page 25
Mummy's Song	Page 26
Shades of Gray	Page 29
Love	Page 31
What Unifies a Community	Page 33
Hope	Page 35
The Song	Page 37
The Dance	Page 39
The Season Ends	Page 41
Underneath	Page 43
Above	Page 45
Sky Light	Page 47
New Palette	Page 49
The Pulpit	Page 51
Formation	Page 53
Rolling Away	Page 55
The Eyes	Page 57
Endings	Page 59
Snow Slides	Page 61

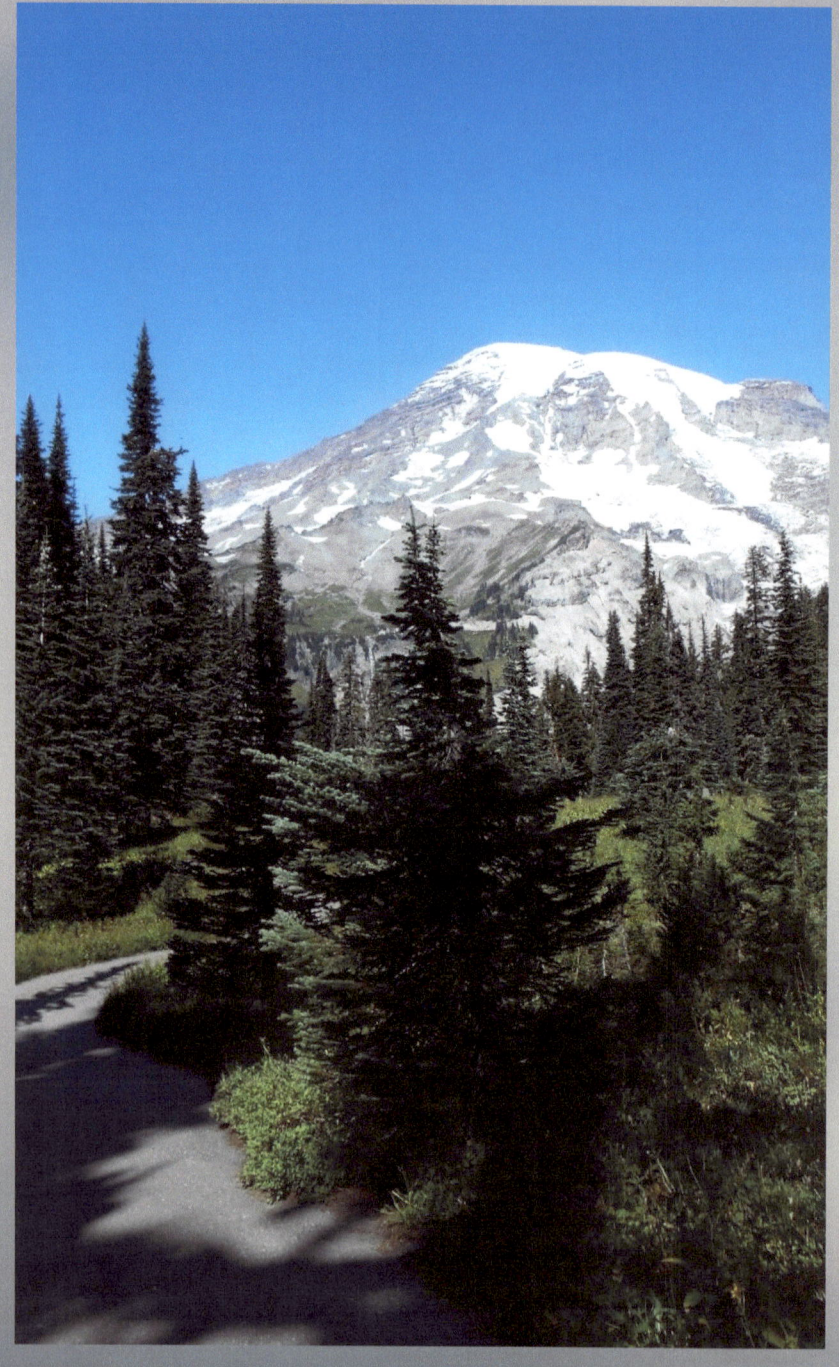

She Is Risen

Blinded by the bright white cone
I stumble on rock
Beating heart burns, eyes blur
Streams carve furrows in my face
But there she is and here I am
Above, beyond, there
And where it all
Begins and ends

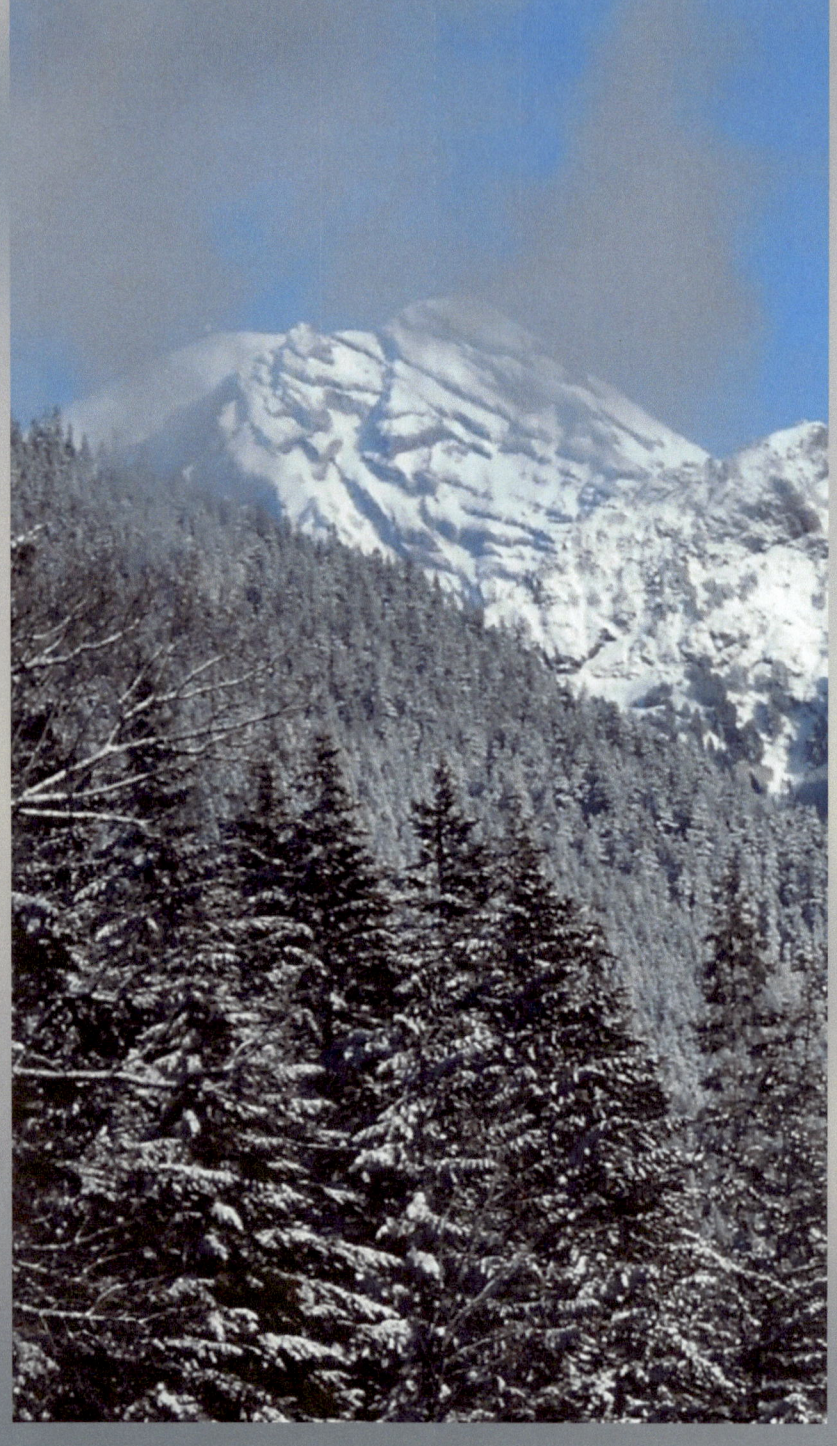

Over the Hill

Something comes through root and leaf
Unravels the knots
Straightens spread of wing and branch
Shows
The way to move through shrinking day
Mist fills the shadows
Paths hidden
Become light
White shapes
In snow

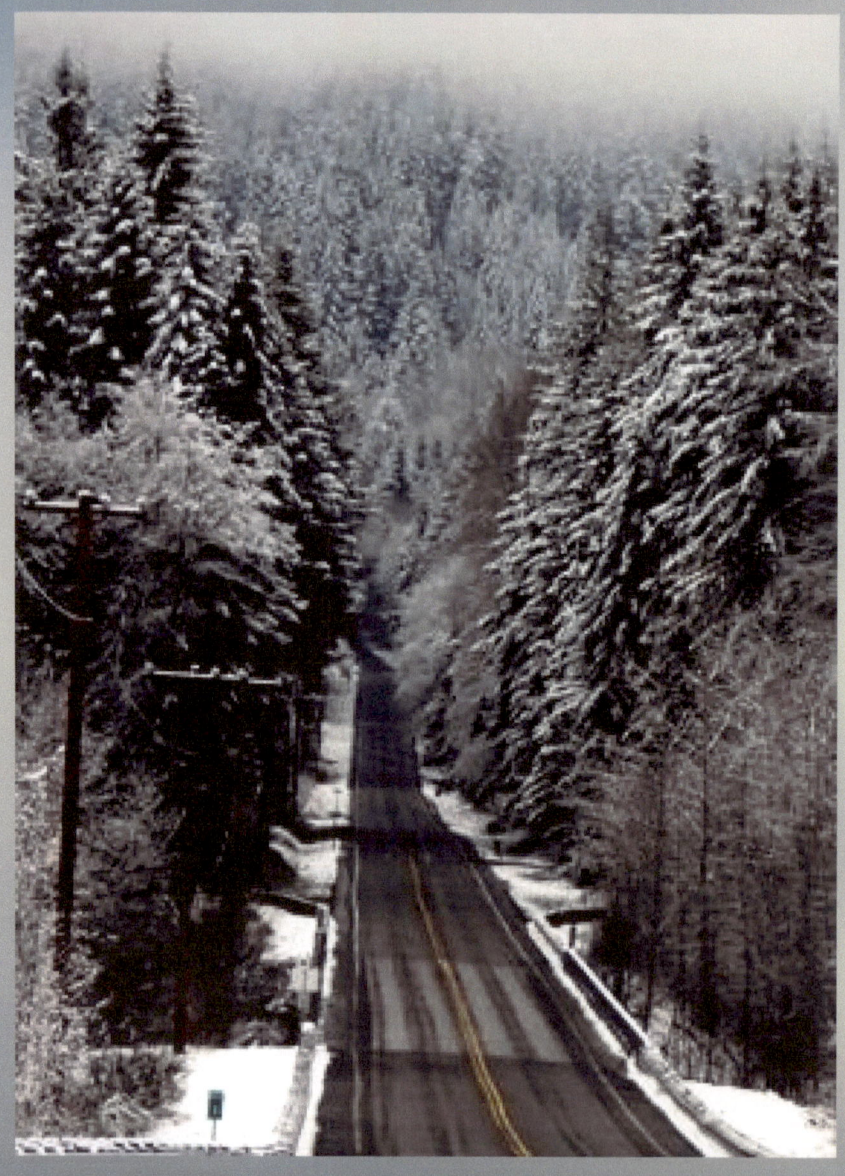

The Way Forward

Slick and sloppy

The way ahead takes careful steps

Destination hidden high

Firs are spurs

Of snow castles

Shadowing those

Who have gone before

Following the golden line

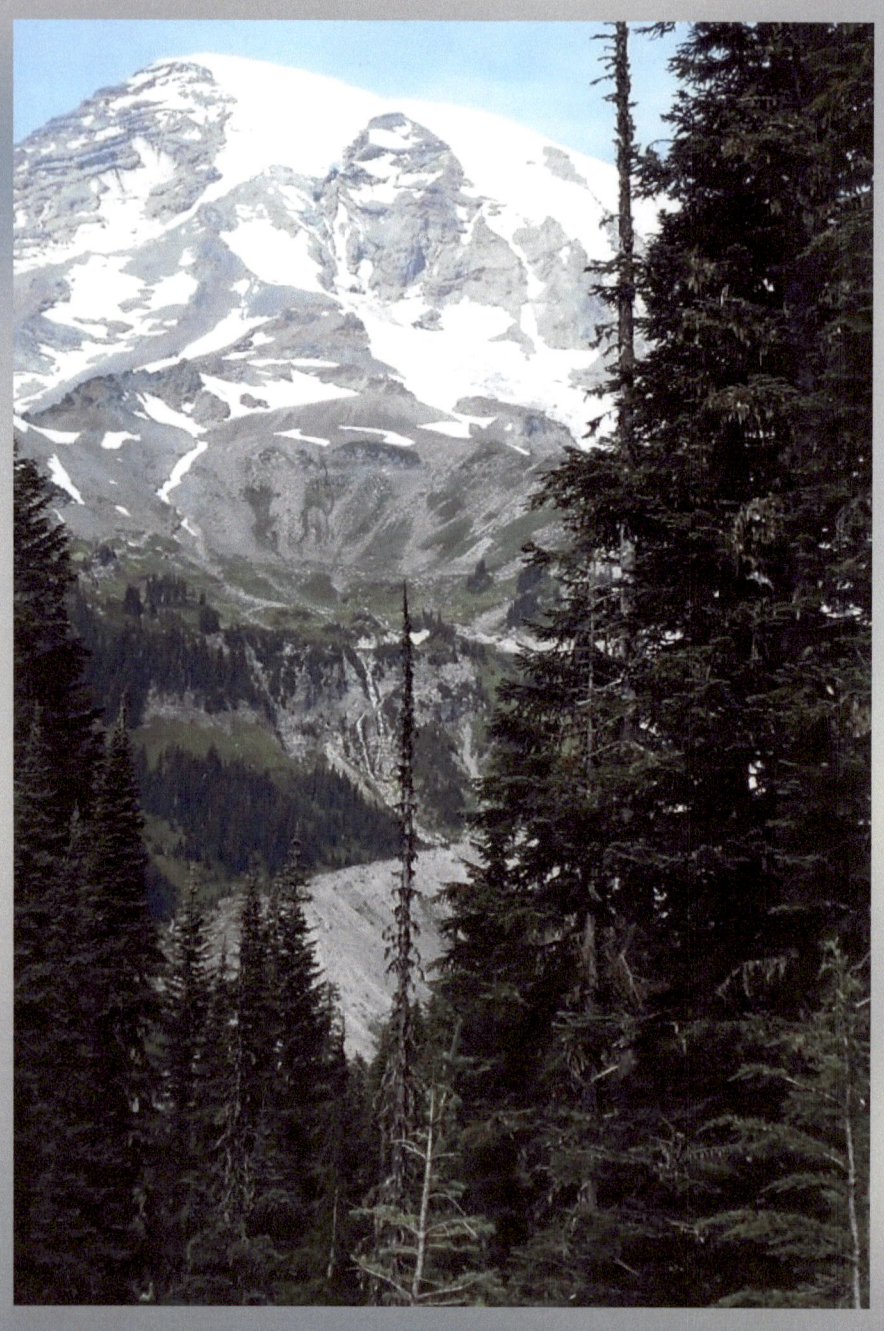

River Birth

Granite legs spread

Ice cuts though ridge and hill

Forms gullies

Grinds boulders into pebbles

Bursts through field and farm

Giving life to those who have forgotten

The terror of its beginning

Millennia upon millennia past

When the mountain exploded open

In labor for the first time

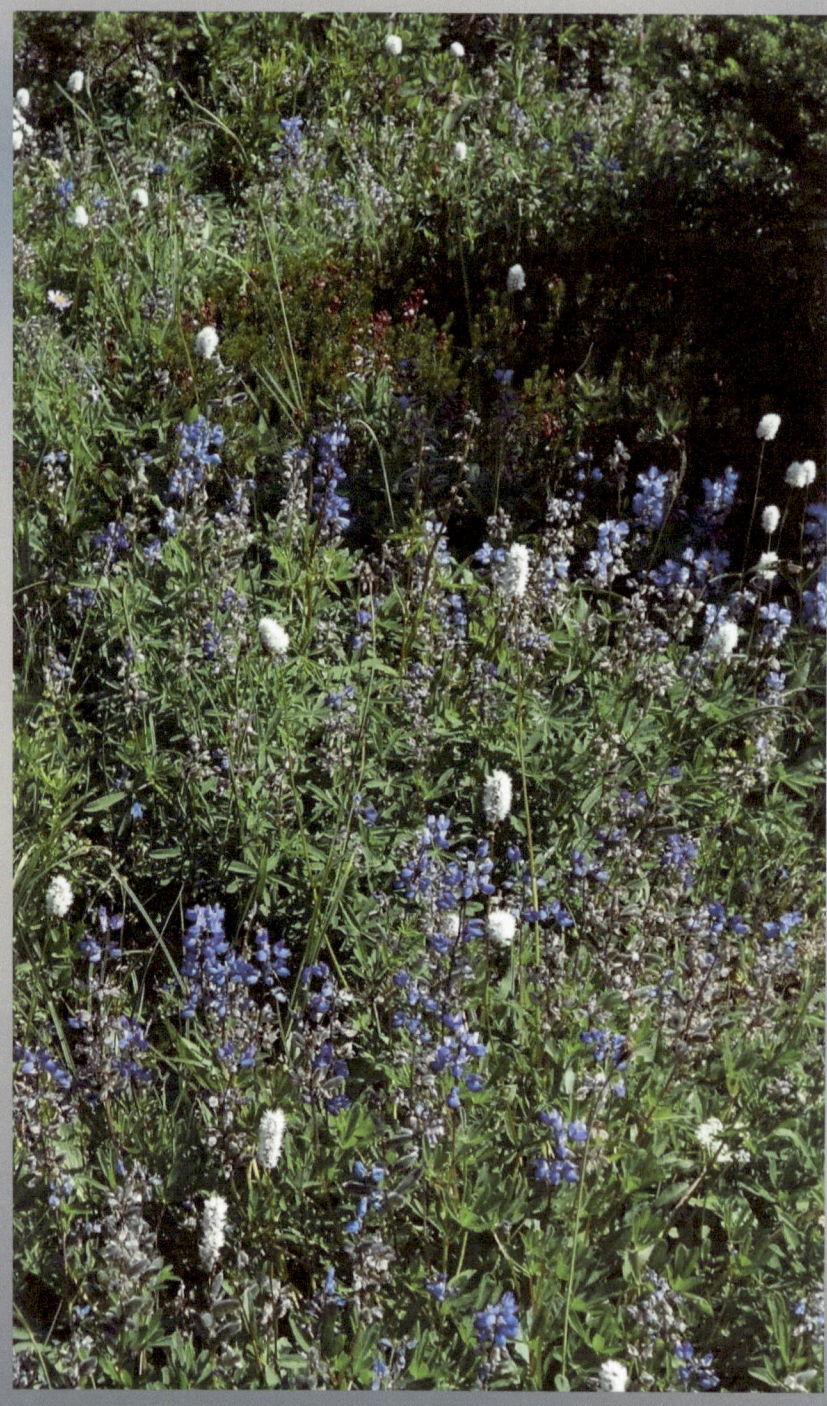

Red White and Blue

High valley blooms patriotic
Bistort white and lupine blue
And bright red pods
Celebrate
Moving in the tart, sweet wind
Holding dew in petal cups
Green and glowing
Opening to the sun
Hiding from the moon
Enjoying each moment
As it comes

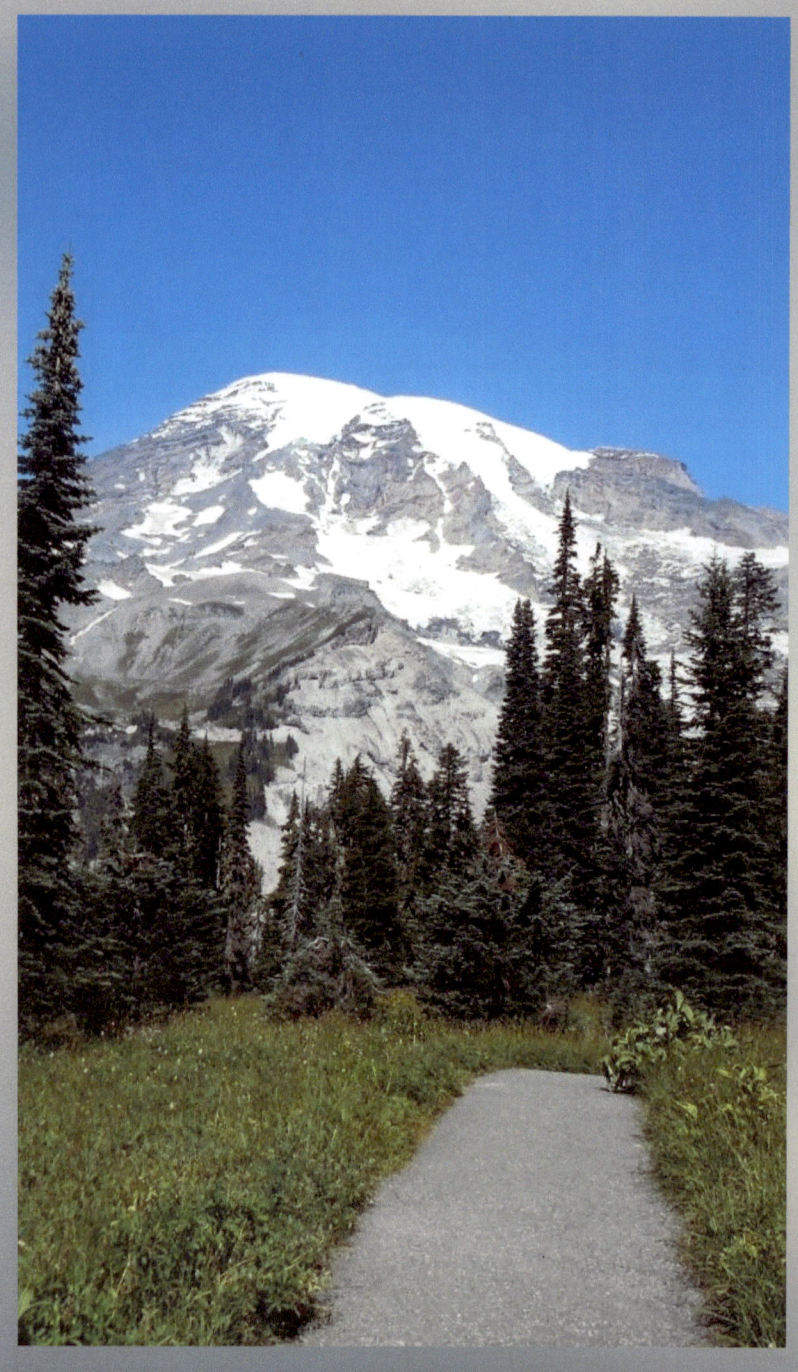

Paved Paths

So easy, going where we know

Suddenly ending

We are poised

To do the expected and then

Beneath us rock, sand and no path

An end, a turn, to where?

Until we look up

White ice and blue air

Eternal future beyond time

Clear for a moment today

Hope and chance mixed with dreams

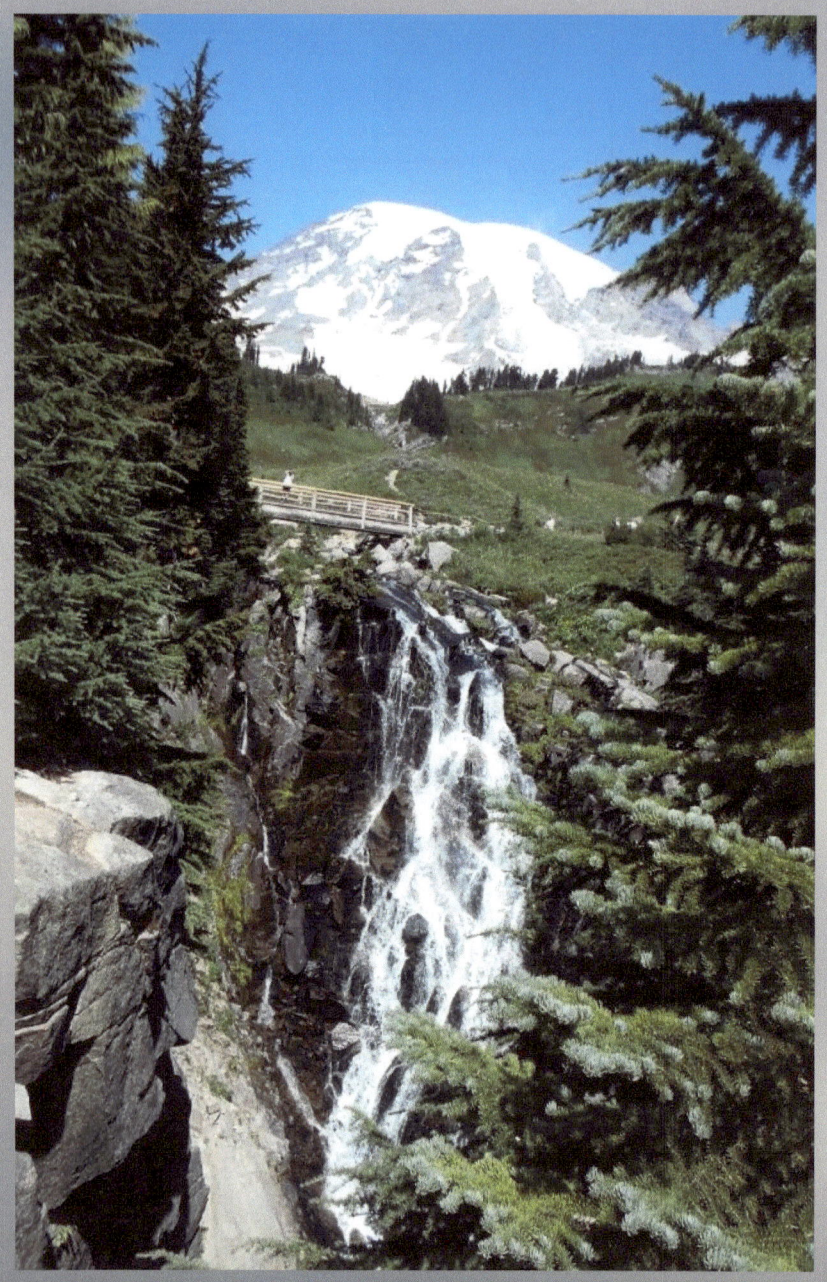

The Chalice

Distills water from volcanic steam

Melting glaciers, rain and snow

Pours crystalline life down

On the worlds below

Tumbling over rock

Etching, enriching, feeding

Until the salt-licked sea

Where clouds

Rise and return

To fill the chalice

To feed the world

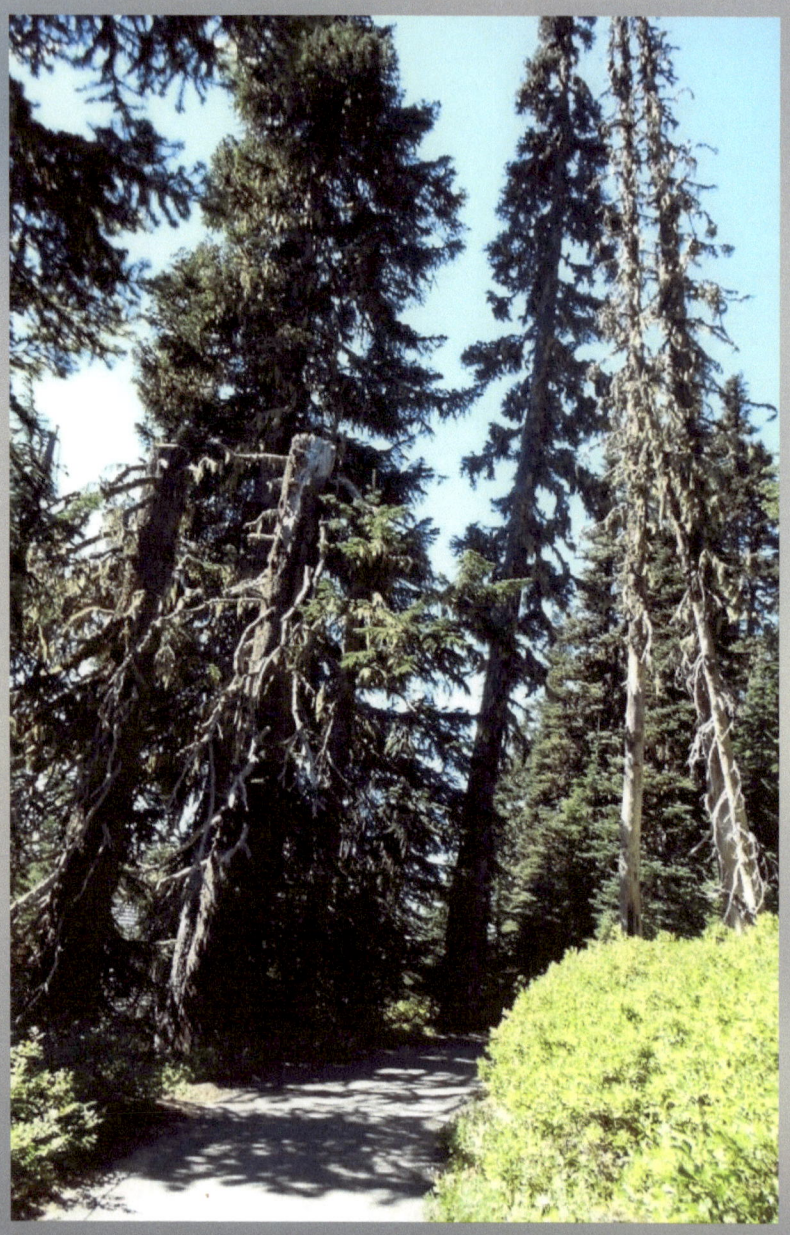

Still Standing

Faded to gray

Boughs bend

Repeating shapes once bright

Now an echo of days past

Winds shape the shriveled bark

Shadows reach, touch and wait for the time to fall

When earth swallows the brittle bones

Feeds new-born sprouts who stretch

To the light, reach for the sun

Until then

Still standing

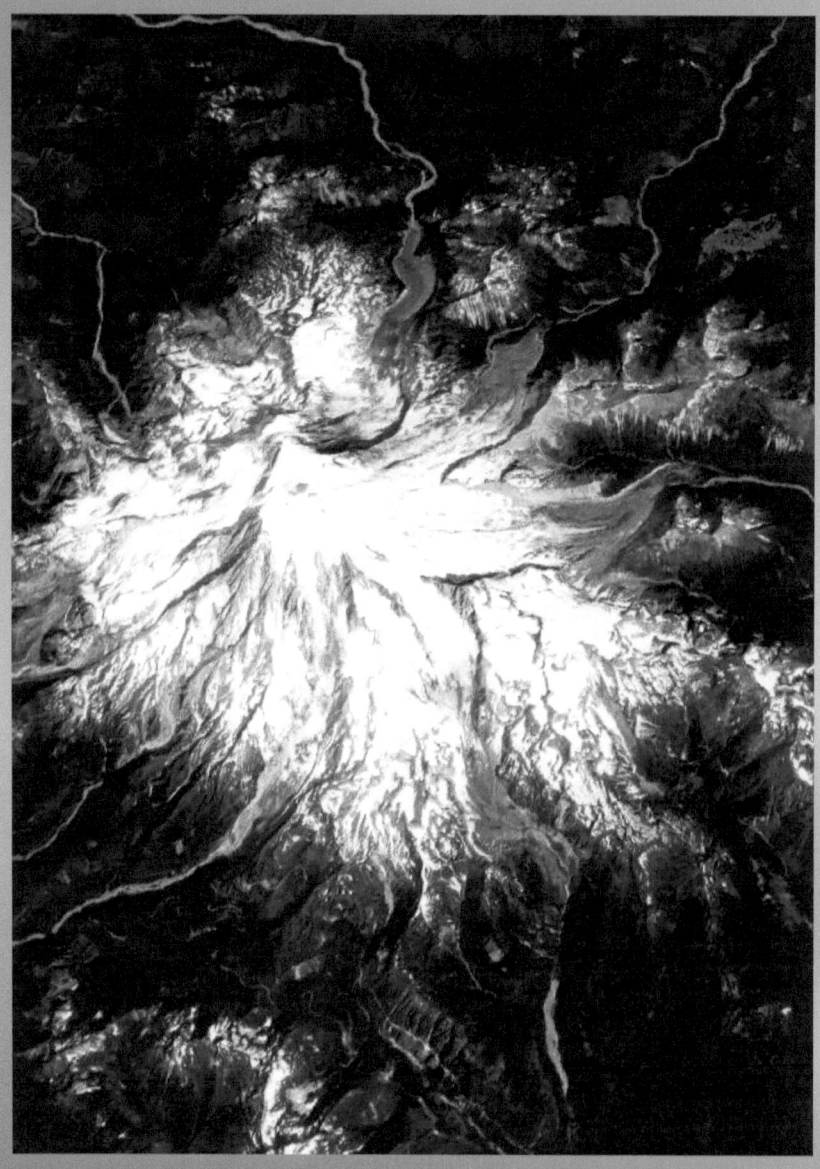

Memoriam

Linked by hope and dreams

They struggle toward

The summit

Six souls fly above the mist

As they fall

Bright white points

Of an earth-bound star

Mark

Their ice-edged grave

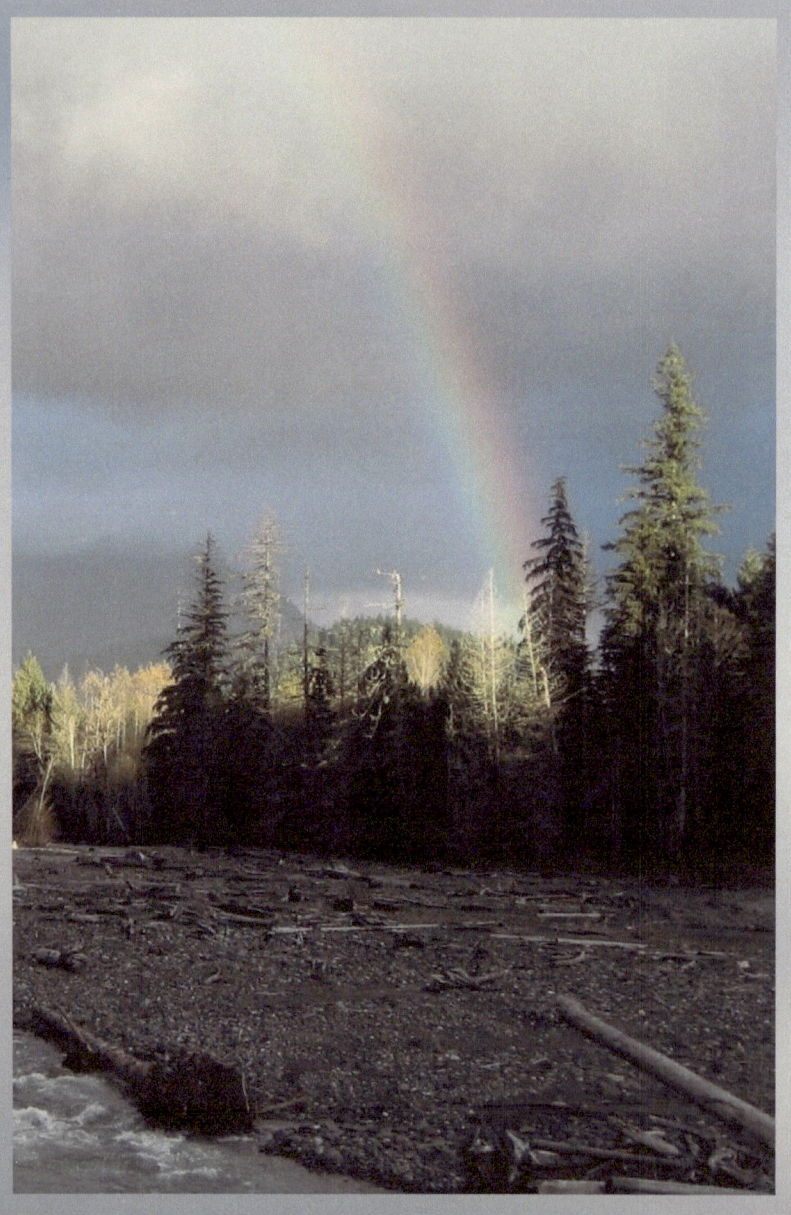

From Psalm 147

"He covers the heaven with clouds

He prepares the rain for the earth"

Light splits the rain

The colors of life band

And brighten where they land

River to river, life to life

Gold born from shadow

Rain and river mingle and glow

In an eternal dance of color and shade

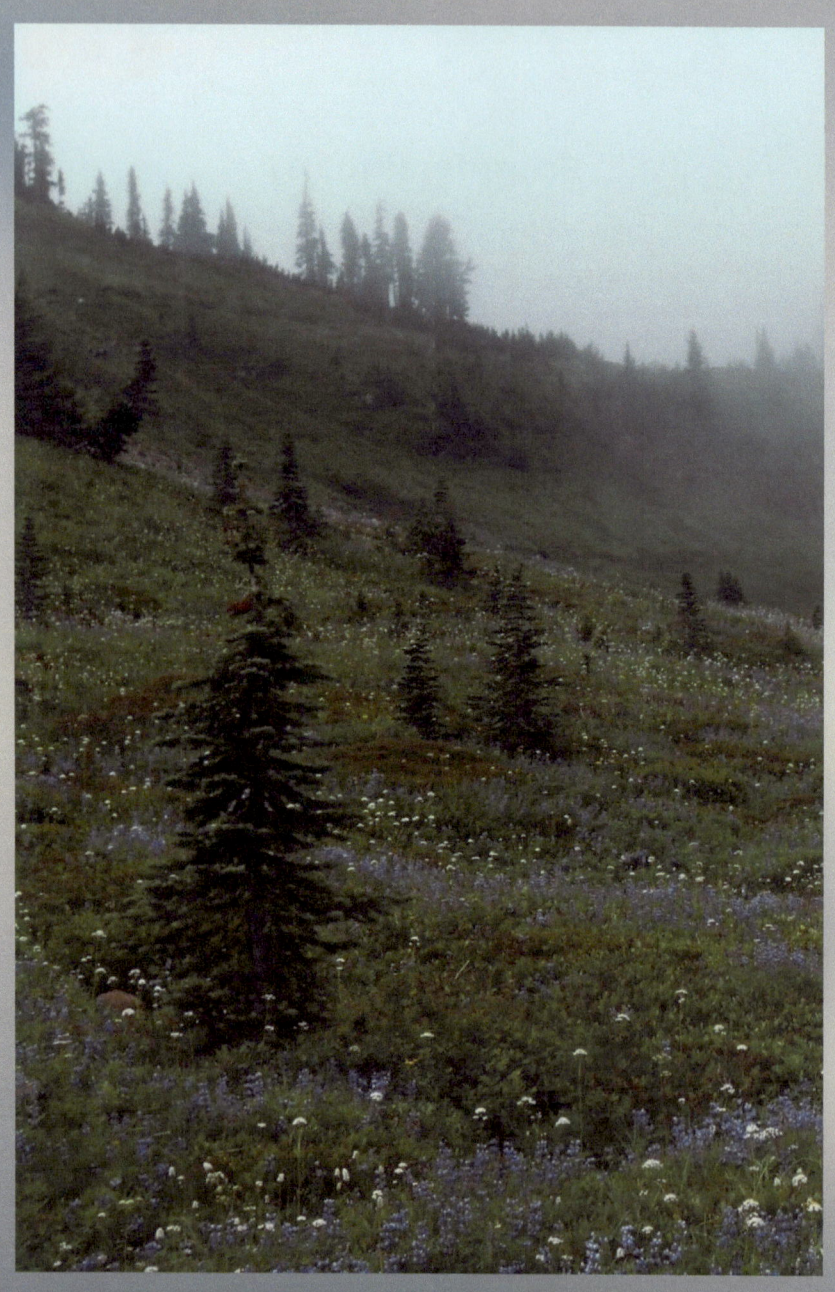

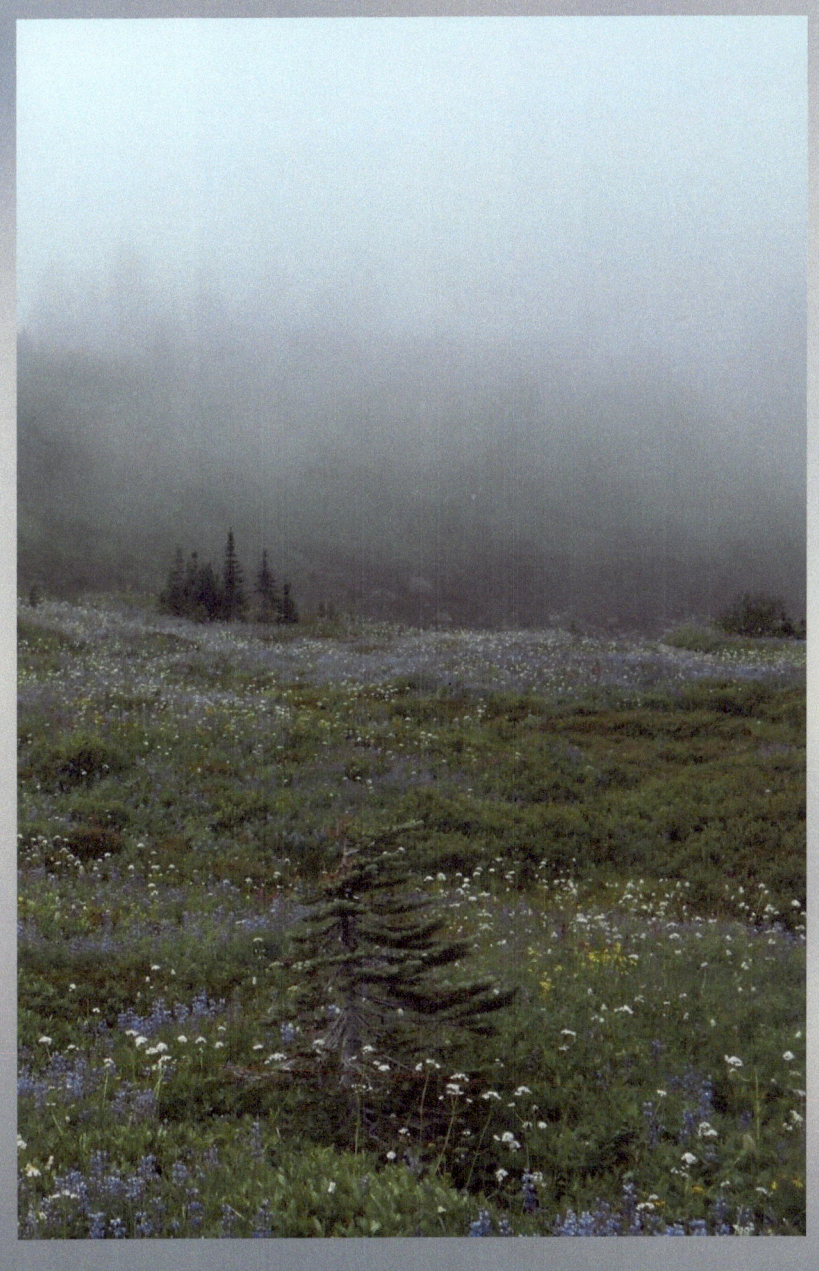

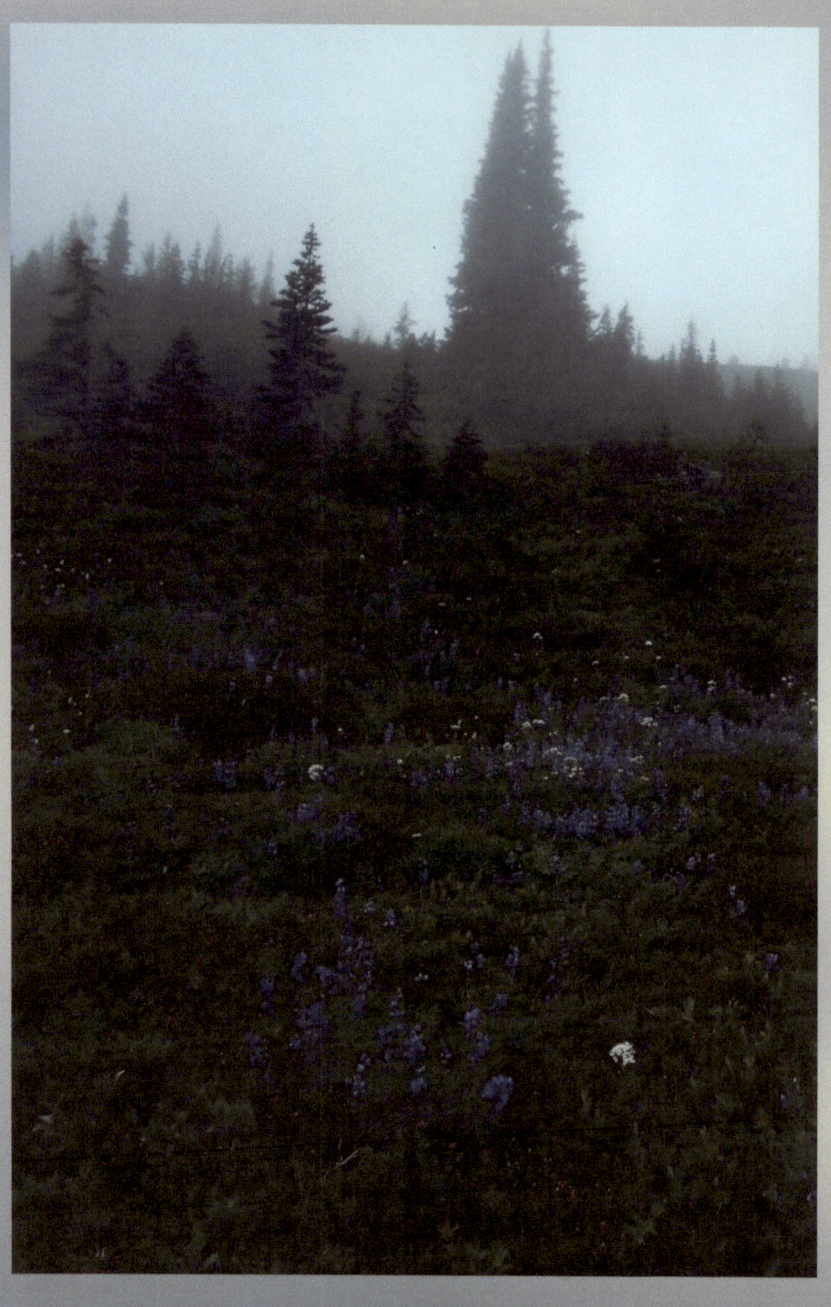

The Mist

In the new light shapes

Brighten and vanish

Heaven is not far away

But lies as a petal or a leaf

Or a shard of light

At our feet within our reach

Swaddled by cloud,

We focus on the near and now

For a moment

We forget the crags and canyons

Waiting in the muffled world ahead

Mummy's Song

I tell myself stories

To pass the time

My eyes are clouds

My ears are silent

No birds can reach me now

No song

No word

No sight or shape

No night

No day

I dream of moon shadows

And tracks of jets by night

I flew once with birds and swam with fish

I ran the hills and laughed.

I can see my children smiling in my mind

I feel their kiss, their touch

As I wait in endless fog

I hold to life by threads of memory.

I cannot hear the angels

I feel their touch, their spirit guiding me home

So long, so far, so now

But I am not ready

Yet

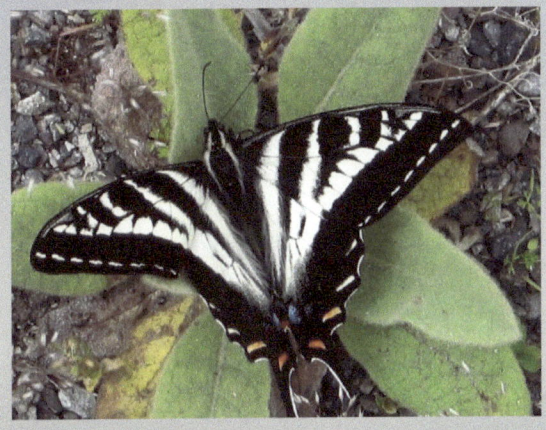

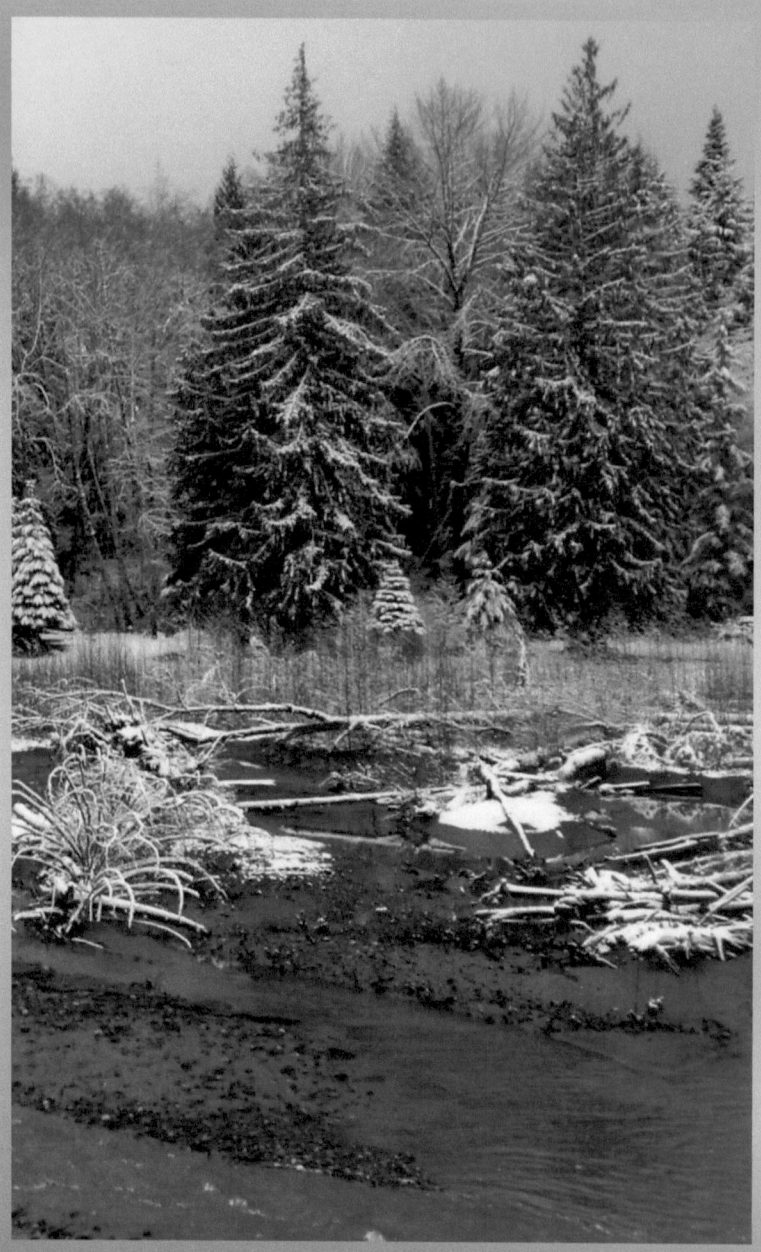

Shades of Gray

In nature's darkroom
Whites can be
Flushed with gray
And black shadows flatten
The ground and the sky.
The year has aged and winter gouges
The river with crags of ice and
Trees droop with the weight of snow
The strongest stand bent but unbroken
The weaker fall and lie on their riverbed
A bright blanket hides their crags and furrows
Until the water rises and washes them down to
The sea where they are born again
As shelter
For new
Growth
Green algae and living cells

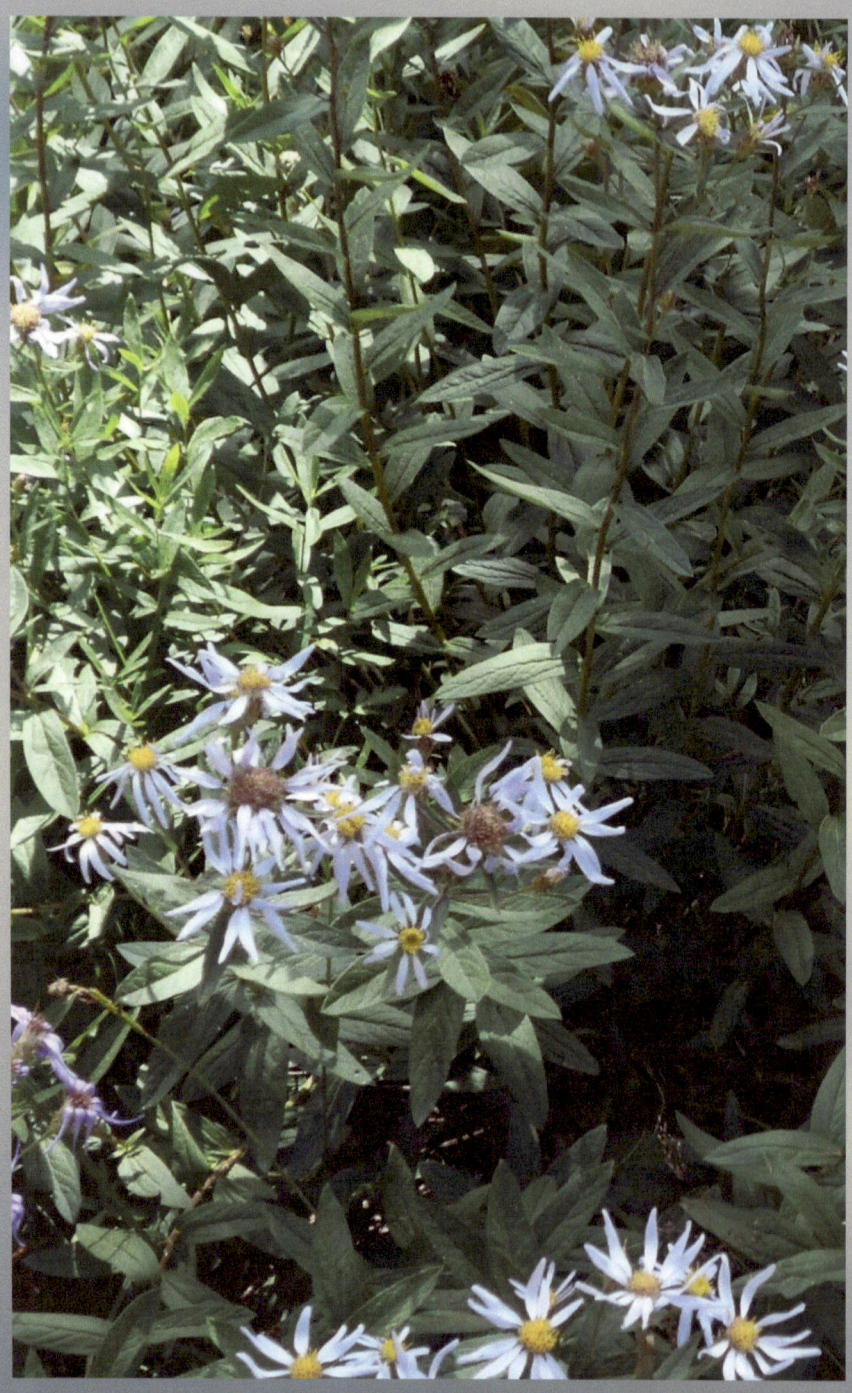

Love

What is it now?

A single perfect moment or

A cluster

Lightning or gentle rain

A bonding, a tearing, a cleaving and an ending

A look back at the burst of glory

A sunbeam for somebody else

An empty field

Petals of the blues

Waiting for dawn or dusk

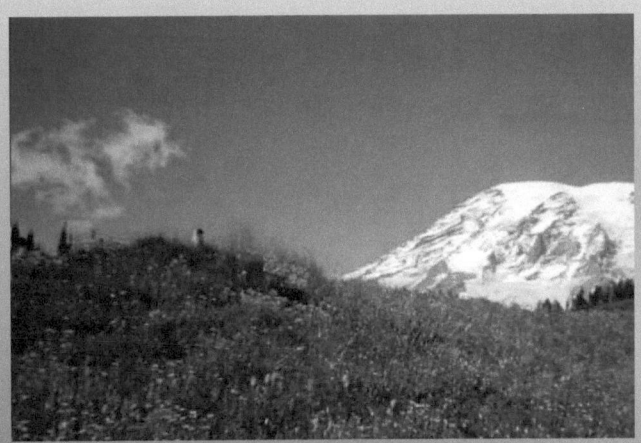

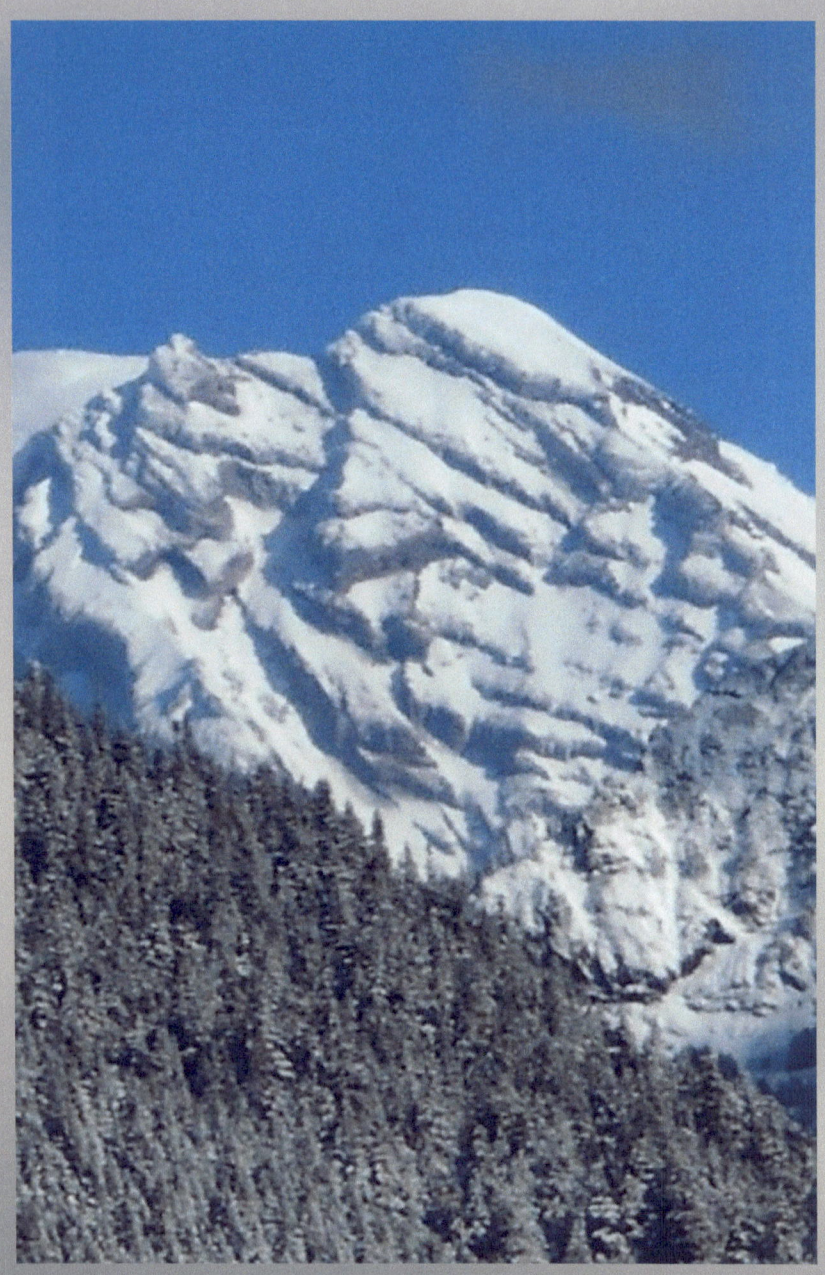

What unifies a community?

The thought of losing it all...

Left with only memories

And images

Of the lives they knew

To pass down the line

To the next generation

Who may never see these crags

The unbroken stands of trees

The way they are now

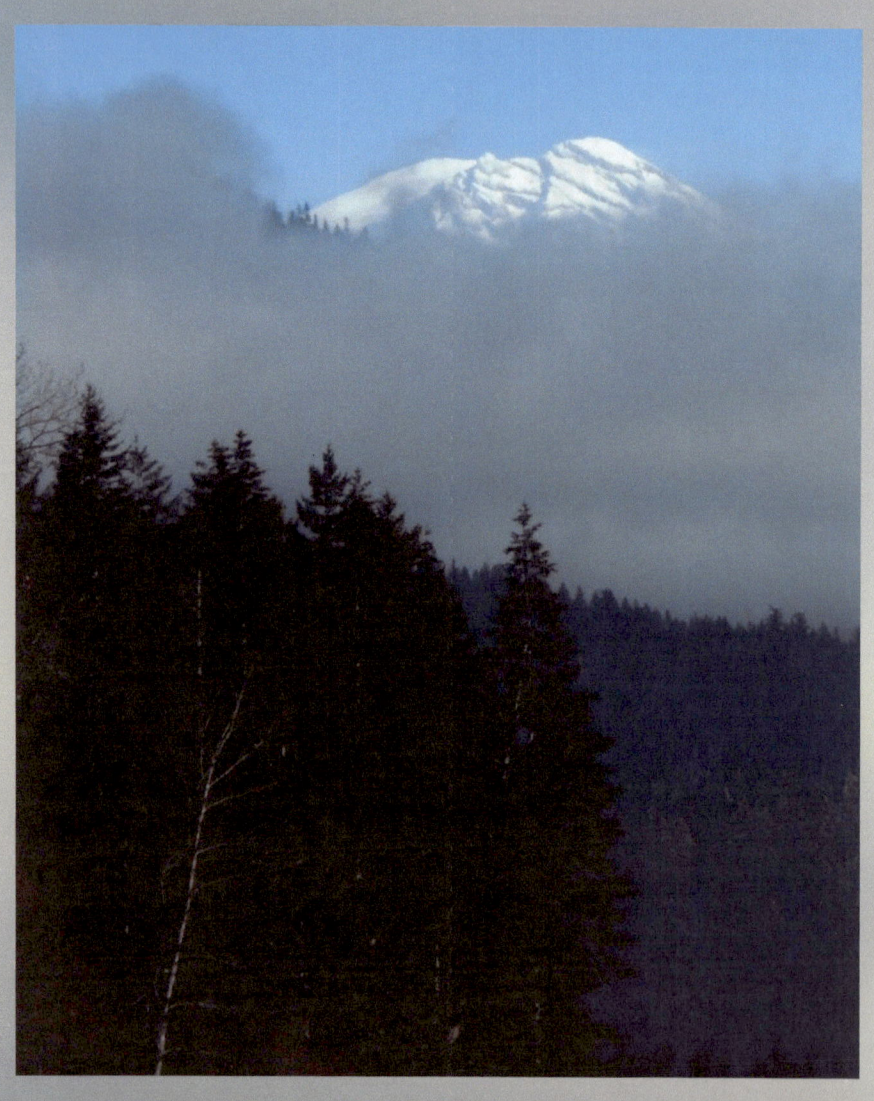

Hope

Vision blocked

By clouds, old events

What ifs

Should haves

Might have beens

Vision clears

Up there

Brilliant against clear skies

The shape of tomorrow is

As lovely as yesterday

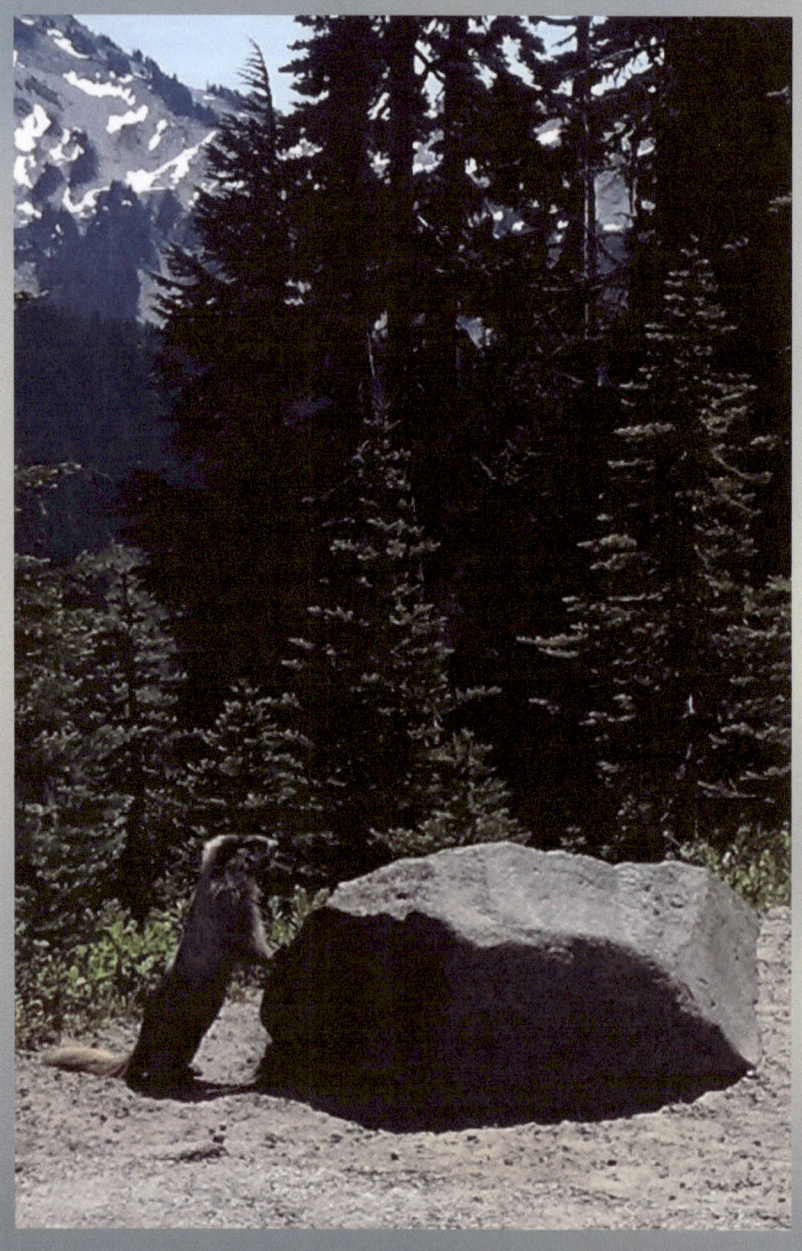

The Song

They sing before they go,

They gather grass and berries

Before the going

Before the bite of winter

Before the snap of frost and ice

So shining, so bright

The fire of a promise

A glorious dance of leaf and sky

Ruby shadows breathing

A celebration

A party

Before

The first snows fall

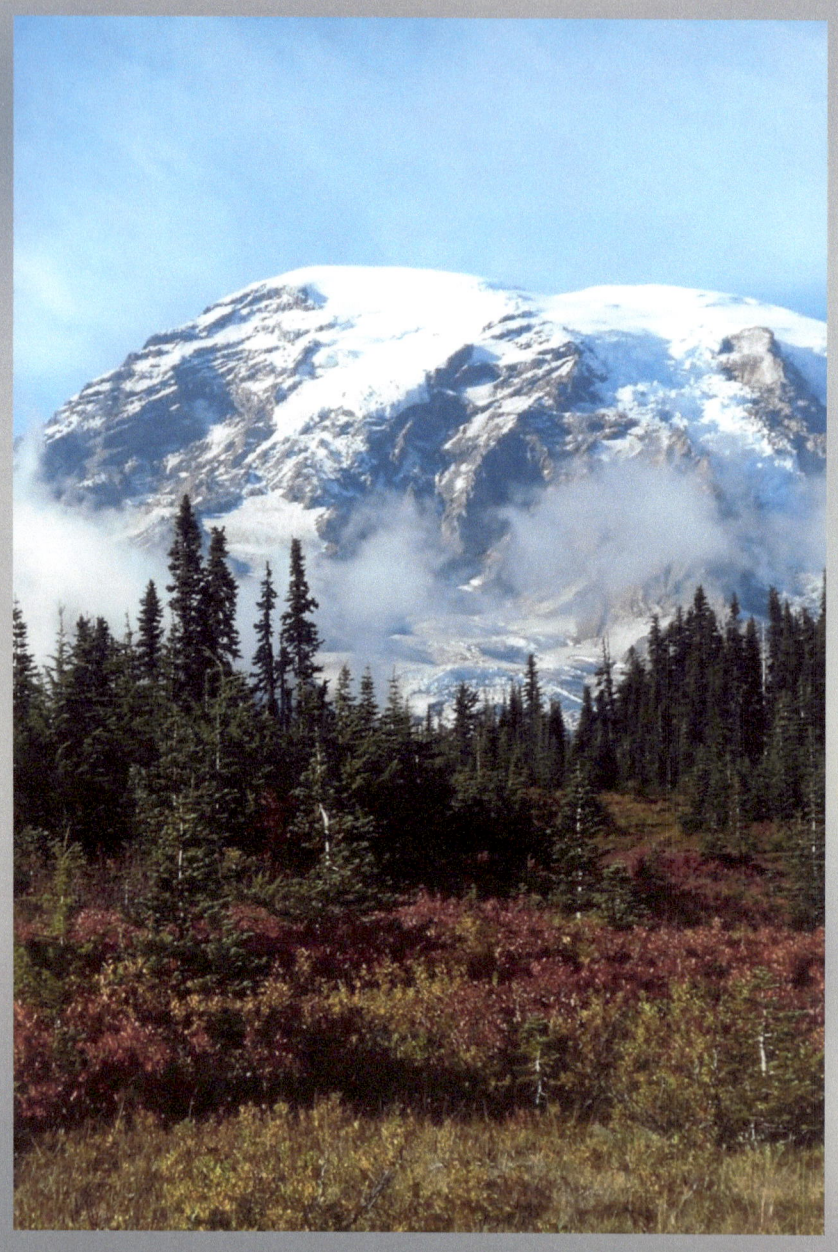

The Dance

Bush and tree wear crimson gowns
Grasses wave golden fans
Diamond snows encircle new-made caves
For now the party rolls
The last moves of flower and fern
The warm waltz of waving fir
The foxtrot of scurrying lives
Rushing, burying, hiding
Storing, digging, lining, building
Bonding, laughing
In the morning mist
Rocking in dens
Rolling through
Shortened days

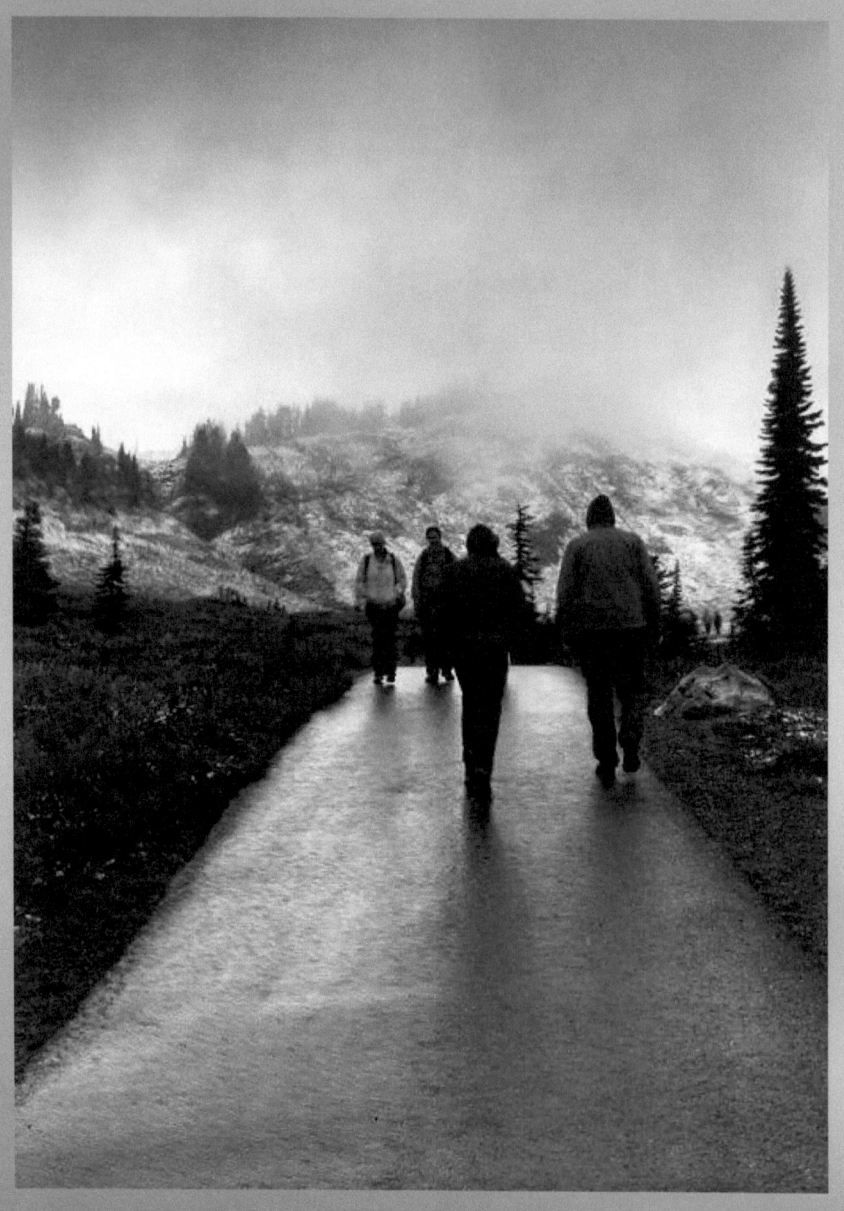

The Season Ends

Even as her bones tremble

Her green grows smaller

Under brown leaves

A breath of hope

With shadows long behind us

Sun at our backs we

Turn to the snow

No shadows now

A line of silver leads us

Ahead to new memories

As we tread

First foot, last foot, sliding up

Or down

42

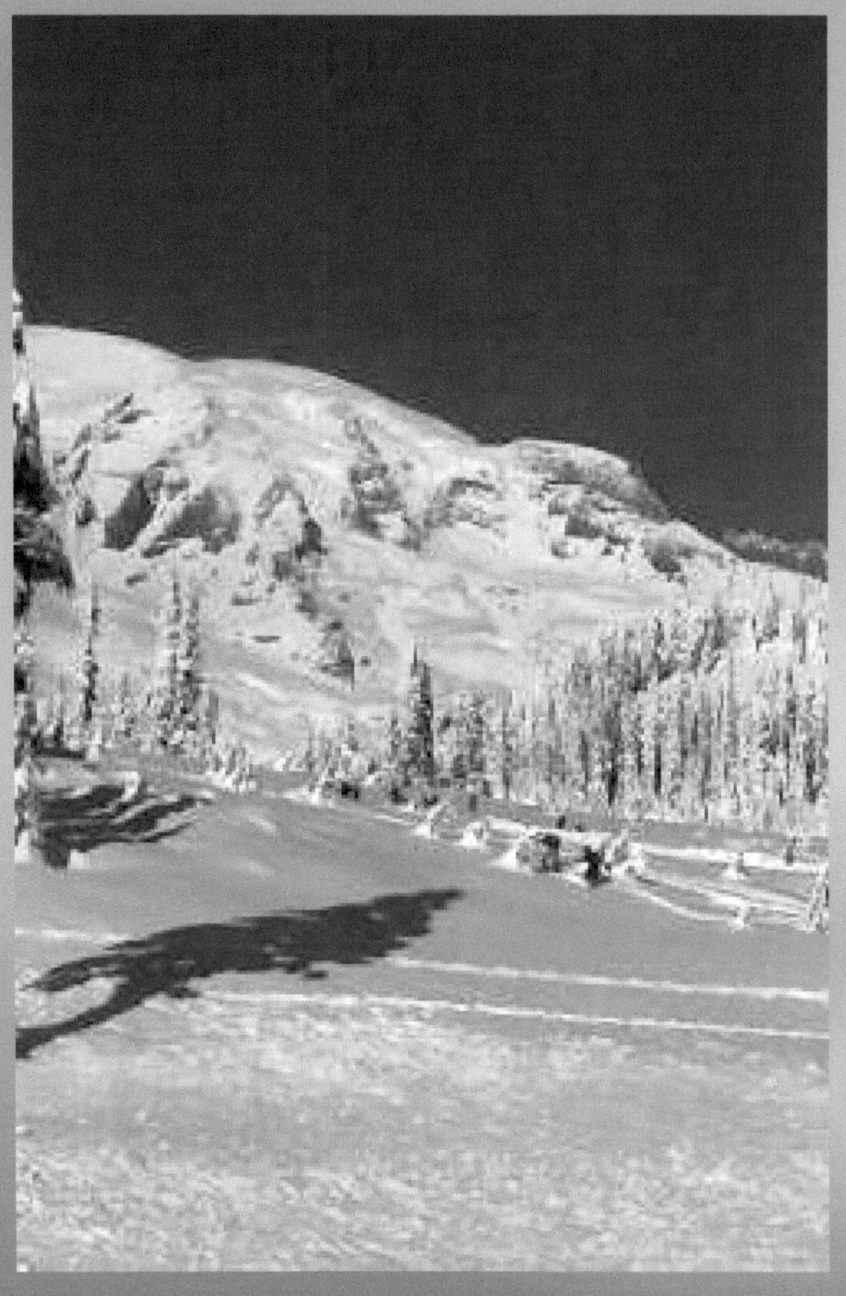

Underneath

Beneath pillow dreams drift

In frozen silence

We sleep under rock and snow

Breathing slow

Waiting for spring

Dreaming of warm wind and rain

The white world unblinking above

Quiet, muffled and there, just there

Spires of peace

Canyons filled

Air sharp and strong

But there is wisdom in the wait

Peace in the seconds

Before the hour we awake

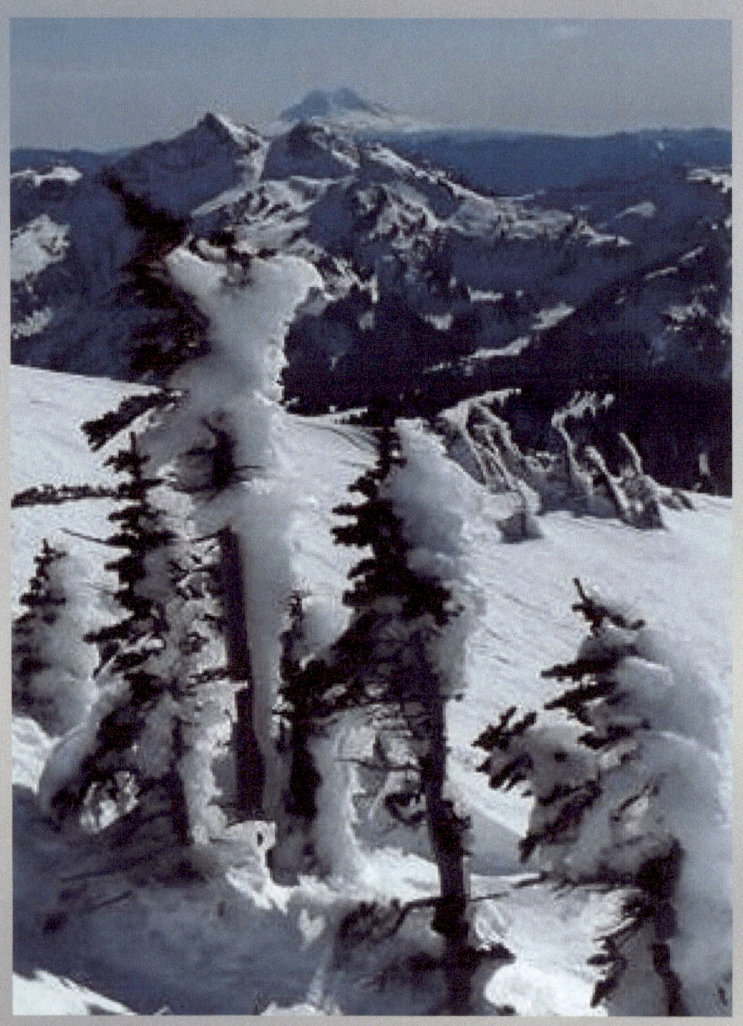

Above

Marble sculptures
Shapes of trees and
Dreams
Bonsai beauty
Where the air is thin
On the edge of
Frozen dreams
Silence stings
Blue air covers
Dark valleys where
Once we walked
Now we sleep still
As branches bend beneath
Solid clouds

Sky Light

She's a harsh mistress
But when she smiles
Cold glitters and diamonds
Decorate boughs
Full and cold
She rises to light
The edge of night
The round door
To dreams and hopes
Until she covers
Her sun and
Dawn colors the dark

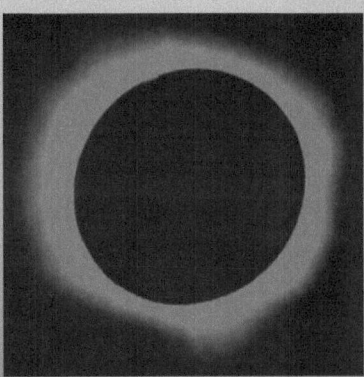

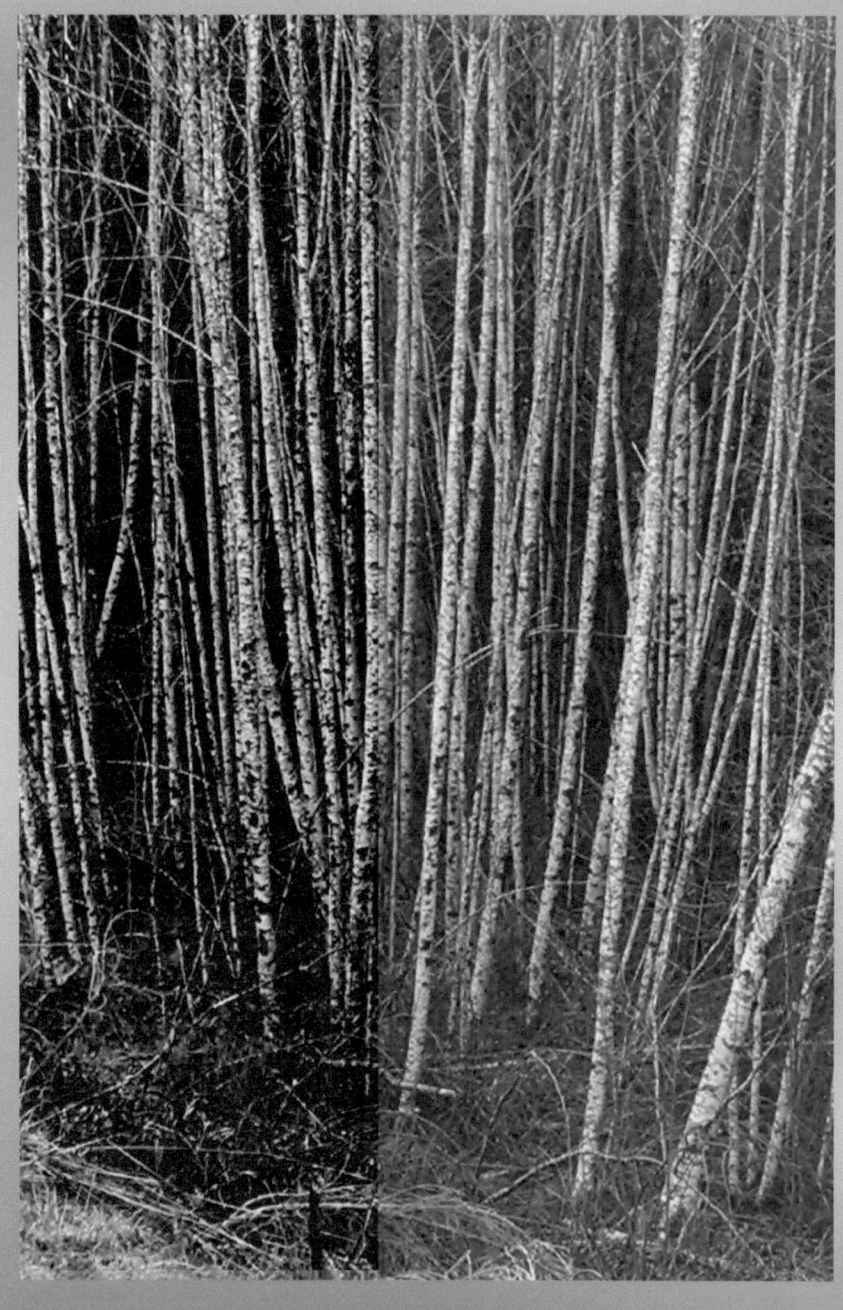

New Palette

Suddenly and slowly

Light paints color where

Black and white

Were once in charge

Now, slowly

A shade of hope, of life

Tints trees and ground

In the valleys below

Where we watch and wait

For the longer day

The warmer dawn

And the spring

In our steps

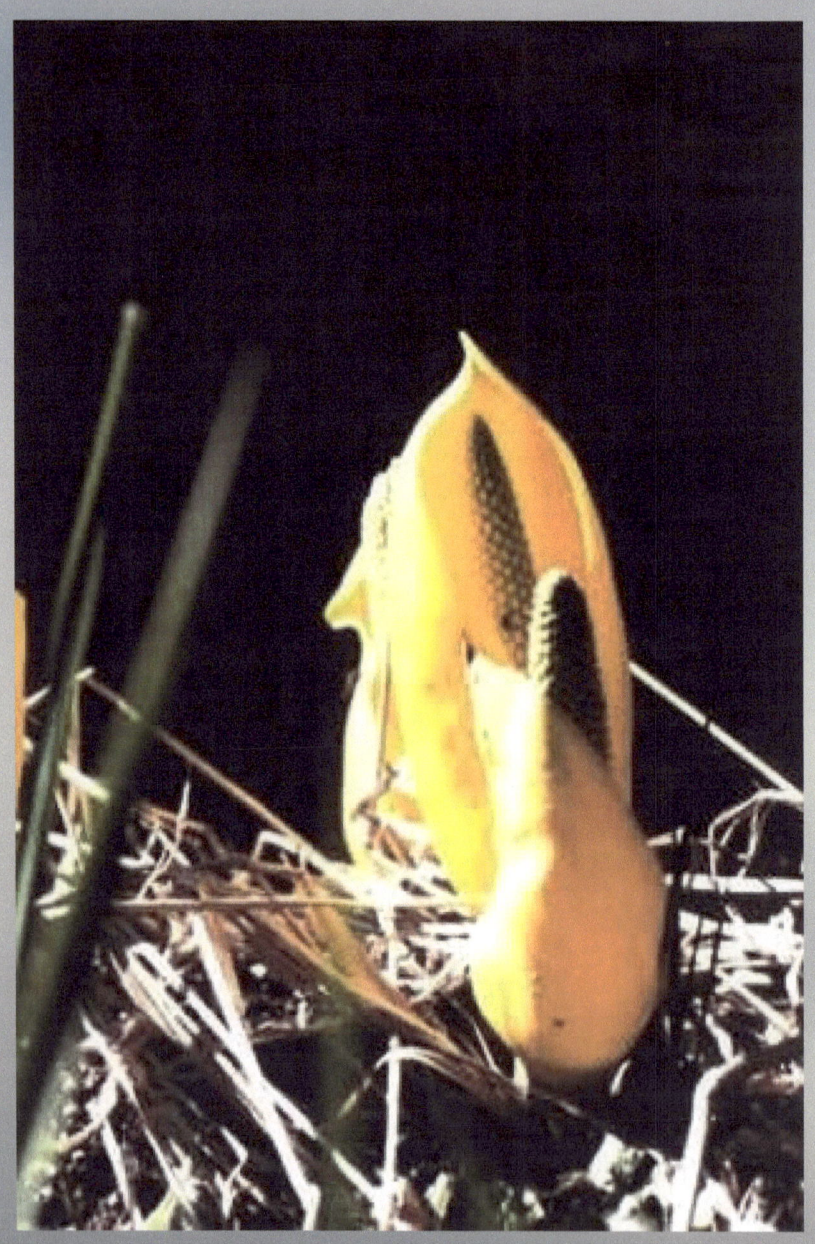

The Pulpit

Shielded from last snows

Above brown brittle grass

The first to rise

Hooded monks

In golden cloaks

First to bring

Shape and hope

To black water

Greeting

The passage

Of time

And the warming sun

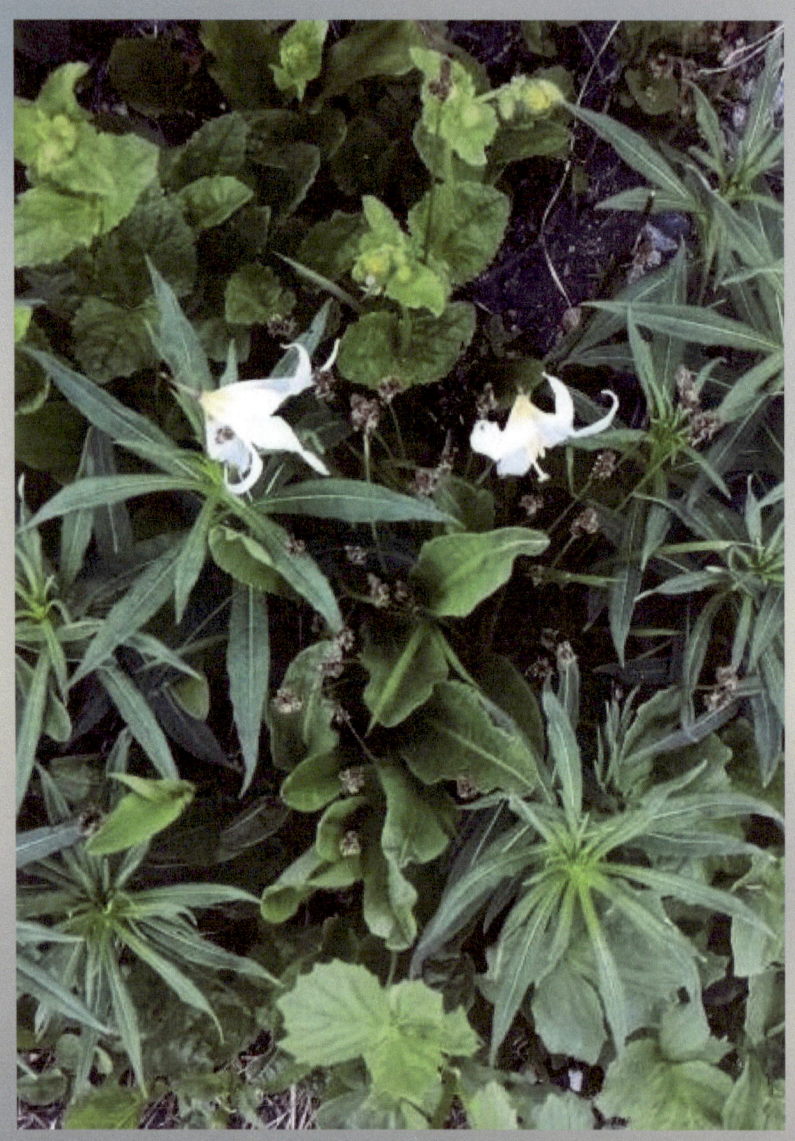

52

Formation

Escaping darkness it knows
When to start life
A green speck in a brown shell
Swelling and breaking
Its shell that becomes soil
While it chooses
To grow a leaf a certain shape
A certain green
Sheltering a fragile bloom
A certain shade
A certain shape
Pushing to the sun
The source
The guiding light
Leading it
To tomorrow
Today

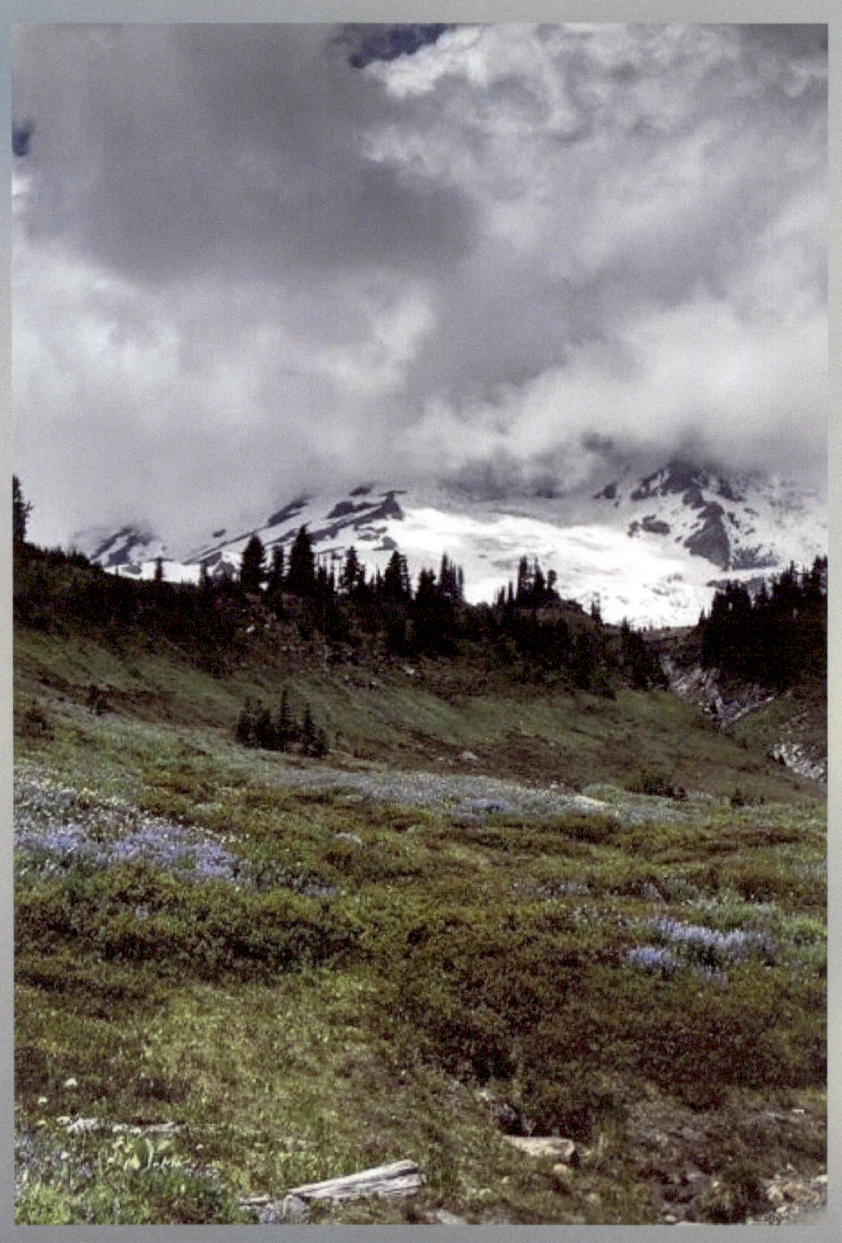

Rolling Away

Melting and moving

White edges of clouds and snow

Define a new day

Where memories bloom

Pink and blue

Birthing from the residue

Of past lives

Soft in the Shadows

A hope

A promise

Of

Gentler times

To come

Trembles

In air still cold

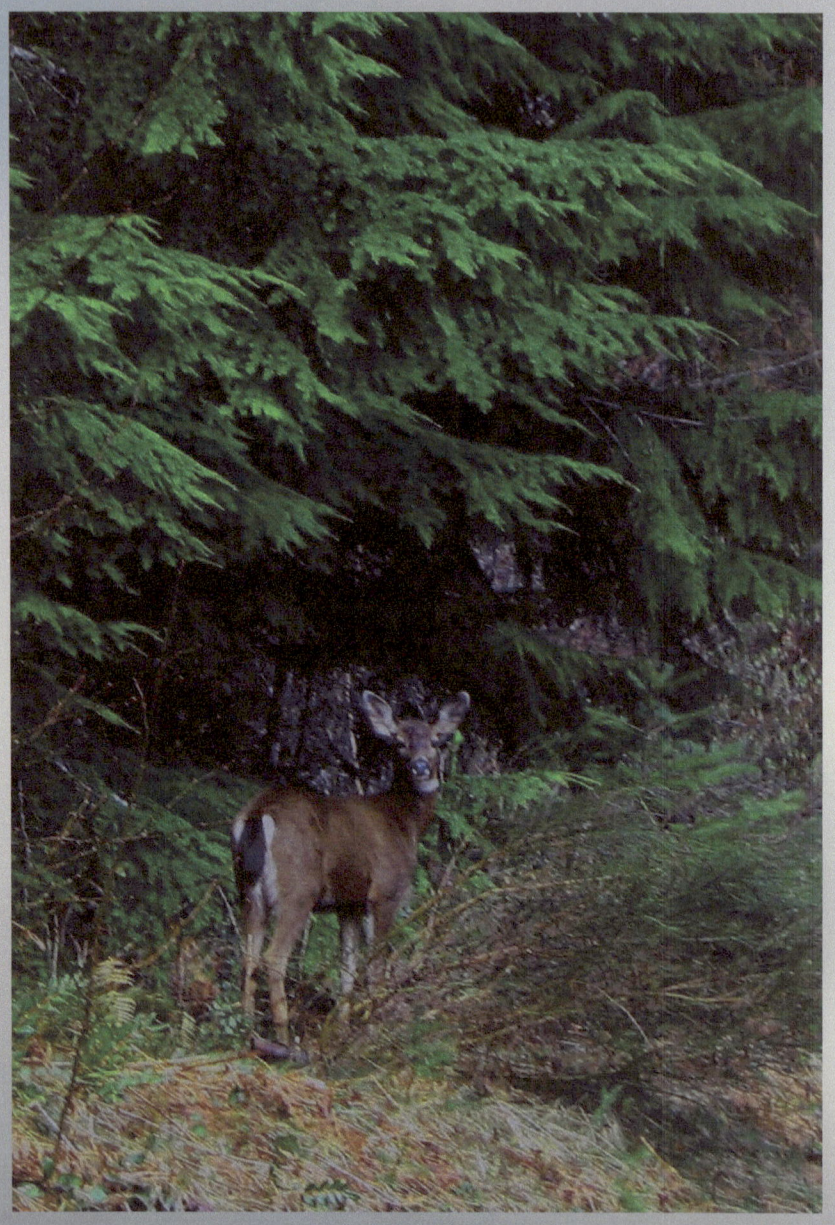

The Eyes

Soft, sweet and trusting

At first

They stare curious

Not sure if we are

Friend or foe

Are we kind

That day?

Or will we

Kill and destroy?

They look, take measure

Blink

And are gone

Not taking

Any chances

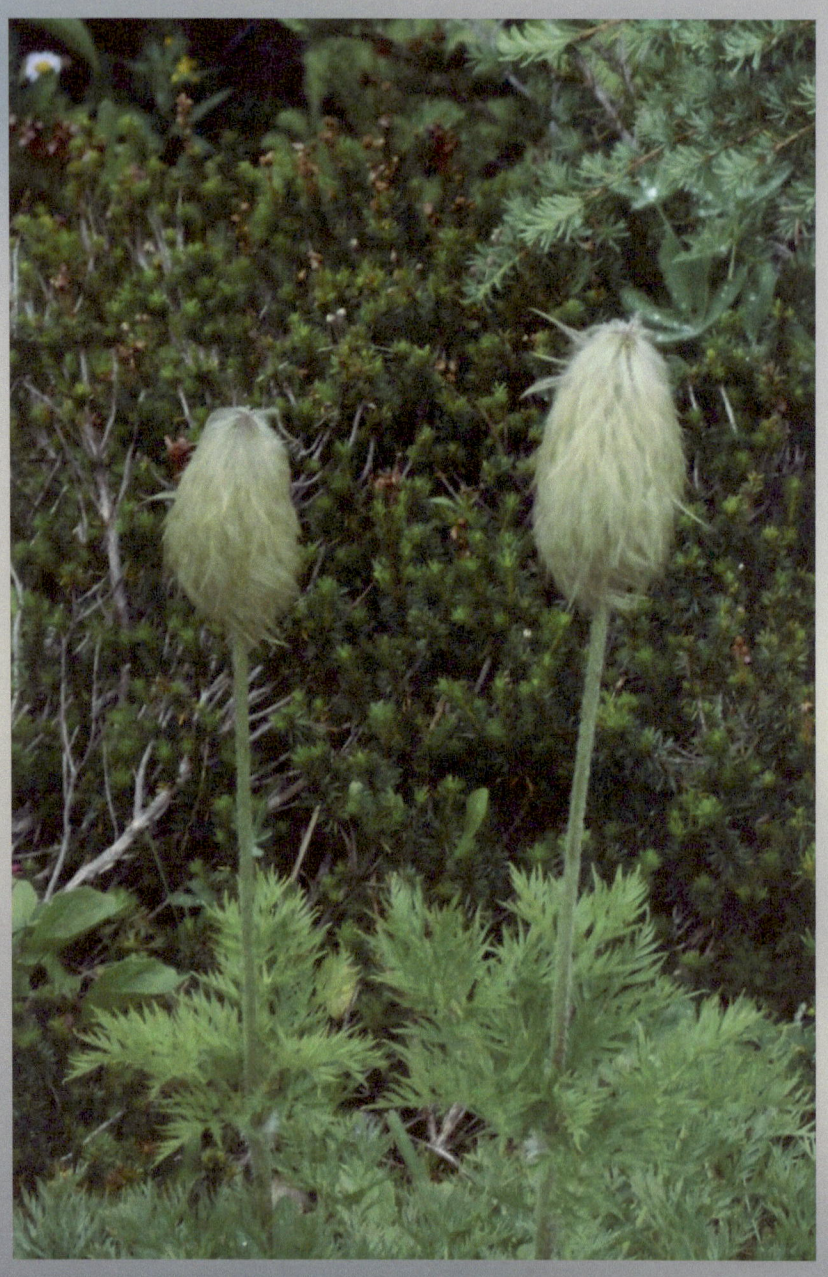

Endings

When our hair grows white
And our feet unsteady
We wave in the sharper winds
Of fall and send our seeds
Away.
To bloom again
Next year
Pasque flowers are
The first to show
The struggle for life
Love and shelter
Is an infinite circle
Our life and love powers
Their journey
And keeps them growing
Until they reach
Their time to sleep

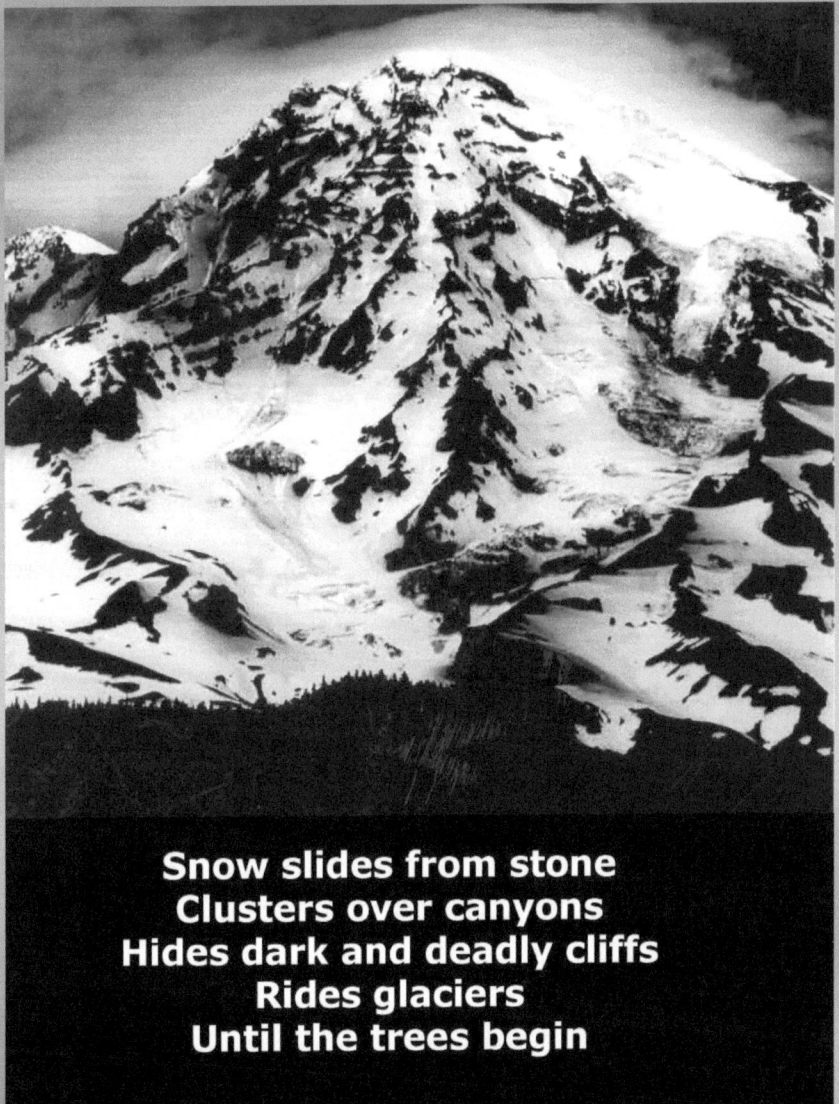

Snow slides from stone
Clusters over canyons
Hides dark and deadly cliffs
Rides glaciers
Until the trees begin

Thanks to...

Mount Rainier

The Park Rangers

The Meadow Rovers

and

All who love our National Parks.

Photography by Eve Dumovich

except for

Donny Sletten photo... Page 44

Stock aerial photo... Page 18

Mount Rainier webcam photo... Page 42

www.ingramcontent.com/pod-product-compliance
Lightning Source LLC
Chambersburg PA
CBHW040848180526
45159CB00001B/353